SOLARIUM

(Prisms, Volume 4)

Lauren Coyle Rosen

Seven Lighthouses

Copyright © 2024 Lauren Coyle Rosen

Cover design by Kyra Grace.

All photographs inside the book taken by Lauren Coyle Rosen in Oslo, Norway, in 2024.

All rights reserved.

*For Jeffrey Rosen,
and for the Light.*

CONTENTS

Title Page
Copyright
Dedication
Storm Past All Gates of Time 1
White Horses Storm the Dawn 3
Upon the Treetops, Sky Levels 4
Steps to Honor Solar Stairs 5
Invisible Birds Dance on Crest 8
Inner Door Knows No Name 10
Symbols that Dissolve Fame 11
Void's Soft Song 16
Gilded Wall 19
Invisible Gates' Bonds 20
Halo Sunset 23
Inner Temple Unwritten 24
Translucent Light that Blinds 27
World, the Grave and Mother 28
Blood Moon's Radiant Plumes 31
Veins of Fire 32
Breathes the Sky 35
All the Tombs 36

What If Piratical Spirits Took	39
Of Spells That Ask Nothing	40
Worlds Beyond What Much Spirit Sees	43
The Supreme Shield of Lore	44
The Serum of Worlds	47
Each Spell of Nightfall	48
In the End, They Drink the Sun	51
Etching Fate	52
Light Washed in Moon	55
Beats the Magma Heart	56
Solarium Fires	59
Suns Unfurled	60
Purest Gold Is Not Drawn	63
Leveling All in Her Gaze and Out	64
Gravel Sunrise	67
Tender Lesson	68
Silver Doors on the Sea	71
Where the Rain Hits Eyelids	72
No Gilded Time	75
Fire Gold Ring	78
Vespers	79
Lavender Robes Dress the Sky	82
Bells That Break the Time	83
Barrier Reefs of Soul	86
Window Bare	87
At Crossroad's One	90
About The Author	93

STORM PAST ALL GATES OF TIME

I

Centers hold the airs of time
Rise from cinders near strewn
Round fountains in planes fine
Lavender chants intone

Storm past all gates of time
Witness seas with shatter
Plaintive notes, dreams refine
Past blood and all matter.

II

Fires alight from stones, heart
Chamber stores, vessels bare
Ascends spire to impart
Truths shed on tendril stairs

Have you once dreamt beneath
Visions unveiled and pure?
Clouds engulf ersatz wreath
Wisdom burns beyond door.

III

Hymns of place without tongue
Whispers at edge of time

LAURENCOYLE ROSEN

Fade in gold twilight hum
Wash through brick house of mind.

Walls dissolve, horizon
Recedes, admonition
Suns with crests emblazon
Timeless premonition.

WHITE HORSES STORM THE DAWN

Fleets of white horses storm the dawn
Whoever flew past gates of sun?
Ever receding, forth as drawn
From the clear divine in full run.

Time with her pretenses of old
Cold salmon, relish, at repast
Silver, porcelain, and flushed bold
Faces the truth of illusions passed.

UPON THE TREETOPS, SKY LEVELS

Plumes of smoke from fire that torches
All detritus untrue, bygone
Pages lit faces in scorches
Of difference with true sun at dawn.

These are the days where winds run free
Upon the treetops, sky levels
All is once forthright as a plea
Abundance of earth's gift revels.

STEPS TO HONOR SOLAR STAIRS

Sundance fires light the airs
Pull the spirits and the hymns
Steps honor solar stairs
Rise to lands with no ends

Eternal light through forms
Like film projection screens
Dreams that float in mind shorn
Of limits to all seen.

LAURENCOYLE ROSEN

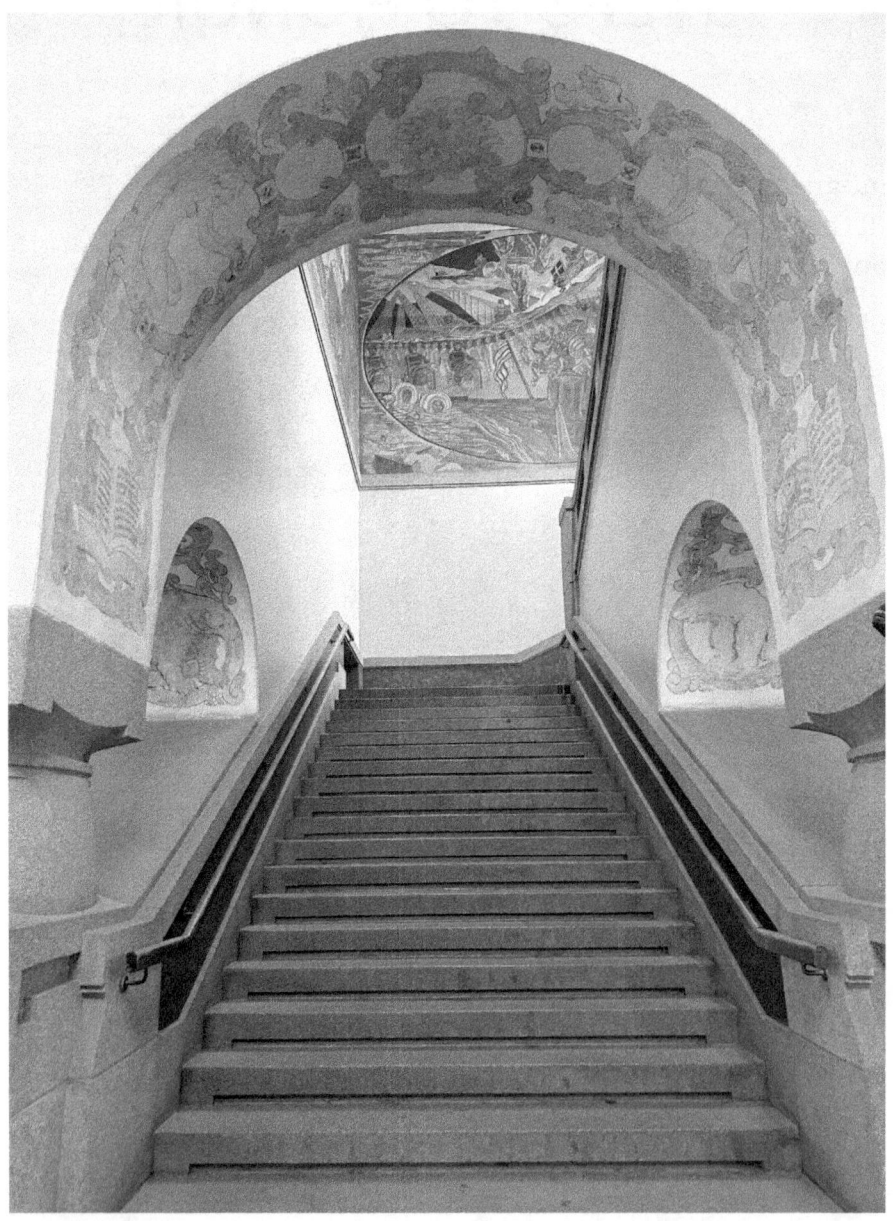

INVISIBLE BIRDS DANCE ON CREST

At the edges of the forest
At the uppermost halo height
Invisible birds dance on crest
Of songs in purest solar light

Falling to ears as the parched leaves
In autumn break tightest of ranks
With branches that swoon in breezes
Surrendering to season's planks.

SOLARIUM

INNER DOOR KNOWS NO NAME

Inner door knows no name
Holds fires that sing of soul
Treasures that blind eyes plain
Yet still accessible

Flights of sonorous high
Winds quench thirst of sun-soaked
Streams, fields, and oceans dry
To salted films as cloaks.

SYMBOLS THAT DISSOLVE FAME

Bleeding through sky and pure fire dance
All that levels the untold truths
Flame that reveals all those askance
Divine mysteries burn through proofs

Who calls rain by her essence name?
Who summons earth, eternal one?
Who eats symbols that dissolve fame?
Who intones sky's beloved sun?

LAURENCOYLE ROSEN

SOLARIUM

LAURENCOYLE ROSEN

SOLARIUM

VOID'S SOFT SONG

Gridiron lights at edges
Worlds upend the time-space
Warp illusions' ledges
Universes erase

Base, dark, calumnious
Acts and deeds and weather
Patterns, souls in chorus
False and ersatz tether.

Blue is the ancient psalm
Lights her eyes with thunder
Resounds through void's soft song
All in searing wonder.

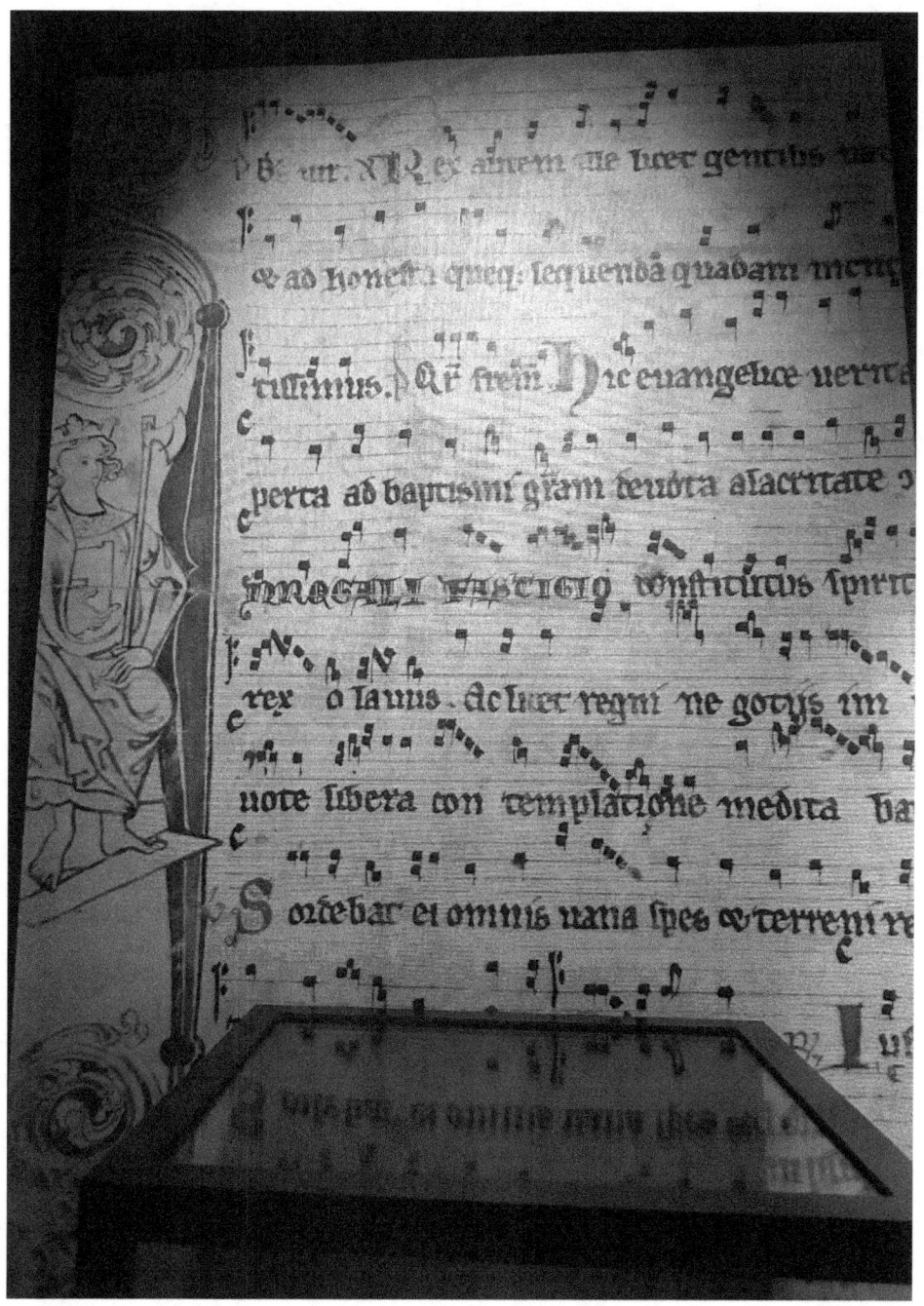

LAURENCOYLE ROSEN

GILDED WALL

Seven hymns tell the blue bygone
Ages with balls and silken eyes
Falling to floors in fits of wan
Enchantress who lights with the rise

Smoke through the room as her level
Shot rings the sky through the crystal
Chandeliers and cries dishevel
Preening crowds line the gilded wall.

INVISIBLE GATES' BONDS

Fate's hand summons the gates
Pythons, fangs, wretched eyes
Dimmest caves, dullest plates
Called minds yet absent wise

Lessons beyond confines
Invisible gates' bonds
Outmoded sullied wines.
Refuse and see beyond.

SOLARIUM

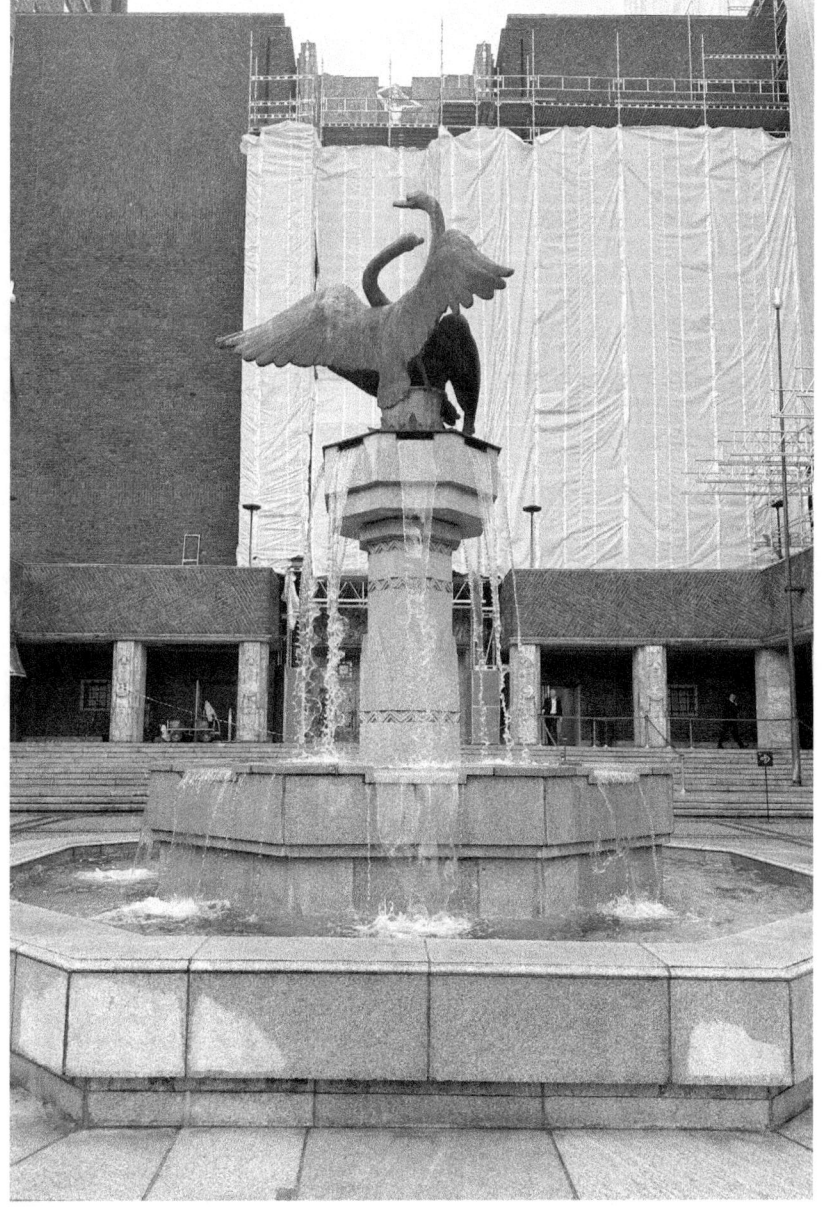

LAURENCOYLE ROSEN

HALO SUNSET

Halo sunset find me ever
On my bare knees in thrall to one
Essence burns through every tether
Of falsehoods to reveal the Sun

Inside us each day rising with
Tides of song and mirth and wisdom.
Each melody arises swift
In minds cleared, find eternal hum.

INNER TEMPLE UNWRITTEN

Gravel path to clearing
Set in tears of the cloud
Dance to end for hearing
Angel tunes play aloud

Scale mountain to hidden
Peak and glory of quest
Inner temple unwritten
Soul keys' highest behest.

SOLARIUM

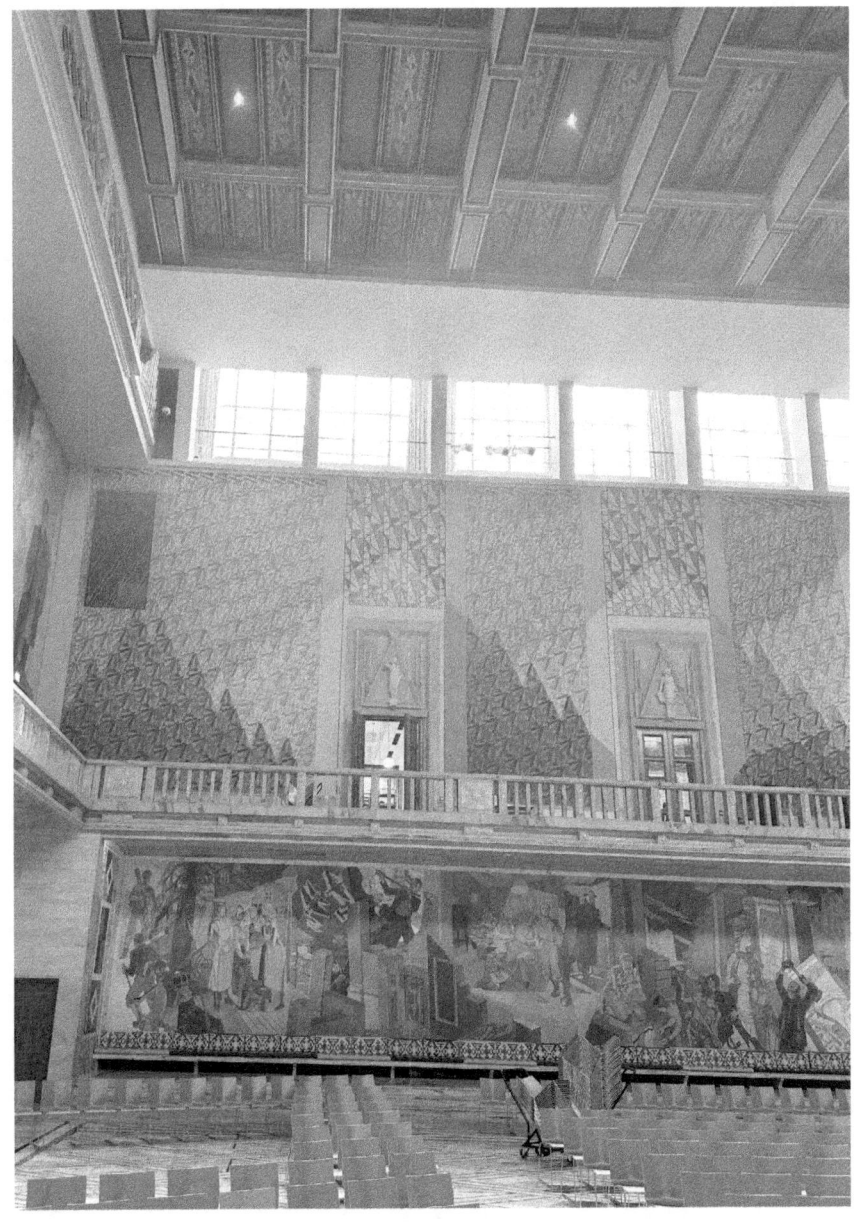

LAURENCOYLE ROSEN

TRANSLUCENT LIGHT THAT BLINDS

Rise to gallows and laugh
You slip through hands of time
Base souls can't hold your path
Translucent light that blinds

Eyes downcast as spirit
Flies to the skies so free
They spoke in counterfeit
Truth ablaze, full glory.

WORLD, THE GRAVE AND MOTHER

Juniper, she gathers
Skirt in concert with winds
World, the grave and mother
Of this plane without ends

Fires of creation's dance
Trees, flowers bend to Sun
Oceans' untamed rhythm
Birds praise in foreign tongue.

SOLARIUM

LAURENCOYLE ROSEN

BLOOD MOON'S RADIANT PLUMES

Tendrils flow from the eyes
Sunlight dawn sears the page
Her face awaits the verdict prize
Relentless in her justice presage

Felt the ever vanquished time
Bygone trades in tired volumes
Skin of angels glisten with wine
Of the blood moon's radiant plumes.

VEINS OF FIRE

Veins of fire pour onto
Her pages lit with time
Falling to ancient soft blue
Garments in sacred rhyme

Would so she ever ask of
Each calumnious wave
Announcing its battle trove
Folly of humans and their rage.

SOLARIUM

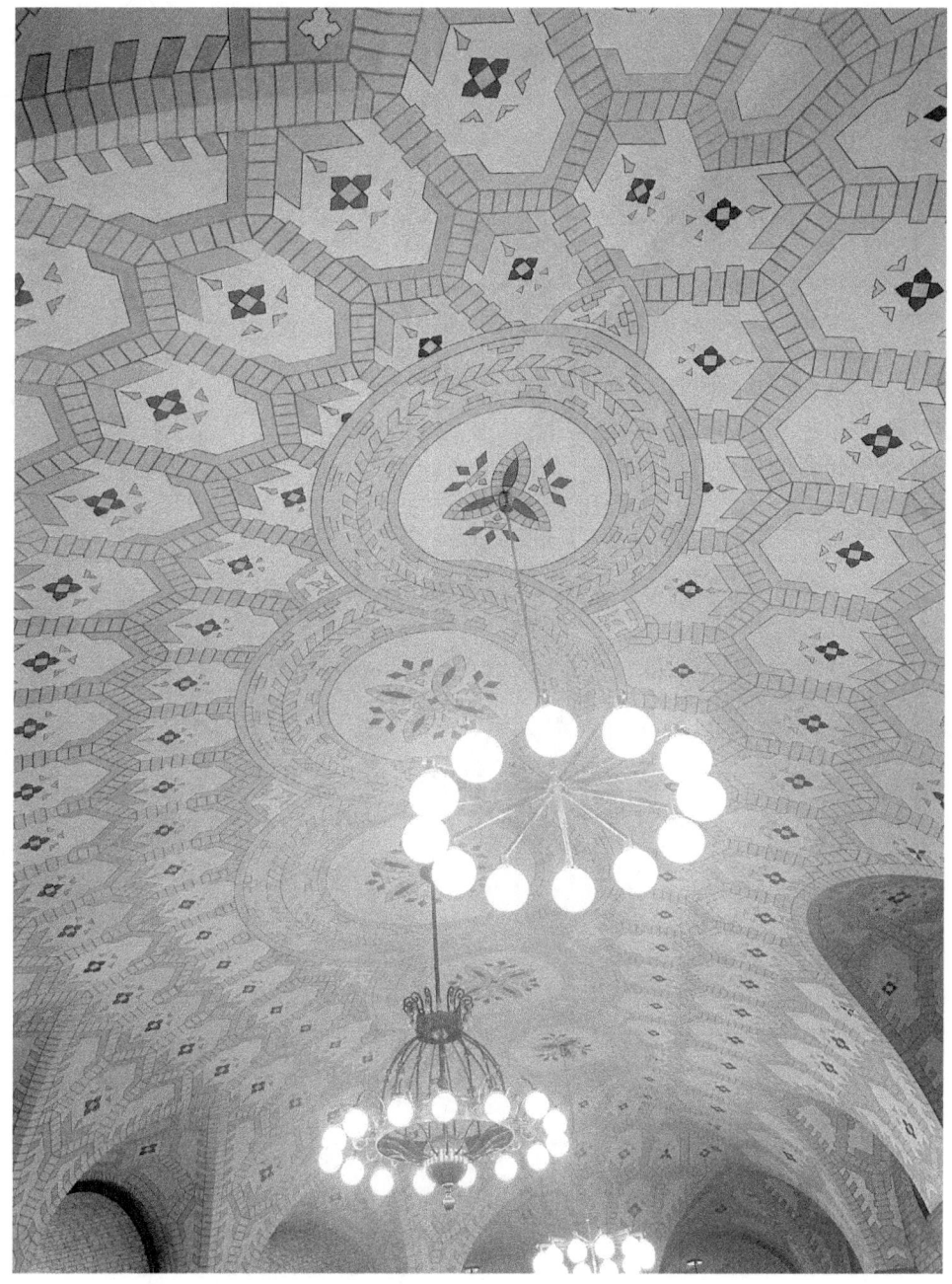

LAUREN COYLE ROSEN

BREATHES THE SKY

Friends with the winds
She asks her surrender
What breathes the sky
To the darkness tender?

Nothing comes to still
Variance that beats on
Every jutting windowsill
Edges of worlds beyond.

ALL THE TOMBS

Itinerant words scratch
The boards of time with base
Recompense feathers, watch
Bell towers and death knell place

Rebirth entails all the tombs
Of time's sinuous ways
Each soul has sacred rooms
Where no violence inveighs.

SOLARIUM

LAURENCOYLE ROSEN

WHAT IF PIRATICAL SPIRITS TOOK

What if a soul were interred
In a body that masqueraded
As true home to a spirit's word
A vessel or temple is paraded

What if piratical spirits took
The force of life from souls
Before us, but beyond the look
Of bodies and days and tolls.

OF SPELLS THAT ASK NOTHING

Ways of the world, the wise say
None exists but all does its dance
Is ever a chance given to soothsay
Truth that is known at first utterance.

The writhing high noon
Of spells that ask nothing
Of truth or virtue in bloom
Only siphon life force for farthing.

SOLARIUM

LAUREN COYLE ROSEN

WORLDS BEYOND WHAT MUCH SPIRIT SEES

Clouds throw silhouettes
Ships cut the waters' peace
Locks of hair in ringlettes
Poison the air with accomplice

Ancient the arrows that reach
To eyes on shores across seas
Invisible and steady they teach
Of worlds beyond what much spirit sees.

THE SUPREME SHIELD OF LORE

Jubilant aces of timing and seasons
Fallow descends and regenerates
Vile tongues trace all ersatz reasons
And clarity of triune contemplates

The mountain top is also ocean floor
All is everything all at once
In this lies the supreme shield of lore
And here there is no future or before.

SOLARIUM

LAURENCOYLE ROSEN

THE SERUM OF WORLDS

Inner realm of oasis without time
The serum of worlds confers life
Pleasantries flutter and fade blind
To the sanctuary beyond all strife

Cave walls fall to vapor within
The great void of universe in all
What have we left but this foreign
Aftertaste, a pretense to enthrall.

EACH SPELL OF NIGHTFALL

Tremble the earth as she wakes
The spirits in streets at the dawn
Stone to the beauty that she takes
Each spell of nightfall is so drawn

Like curtains on world that keep
Relieving us of all we try not to see
In visions of dreams we still sweep
Floors of souls and the truths to be.

SOLARIUM

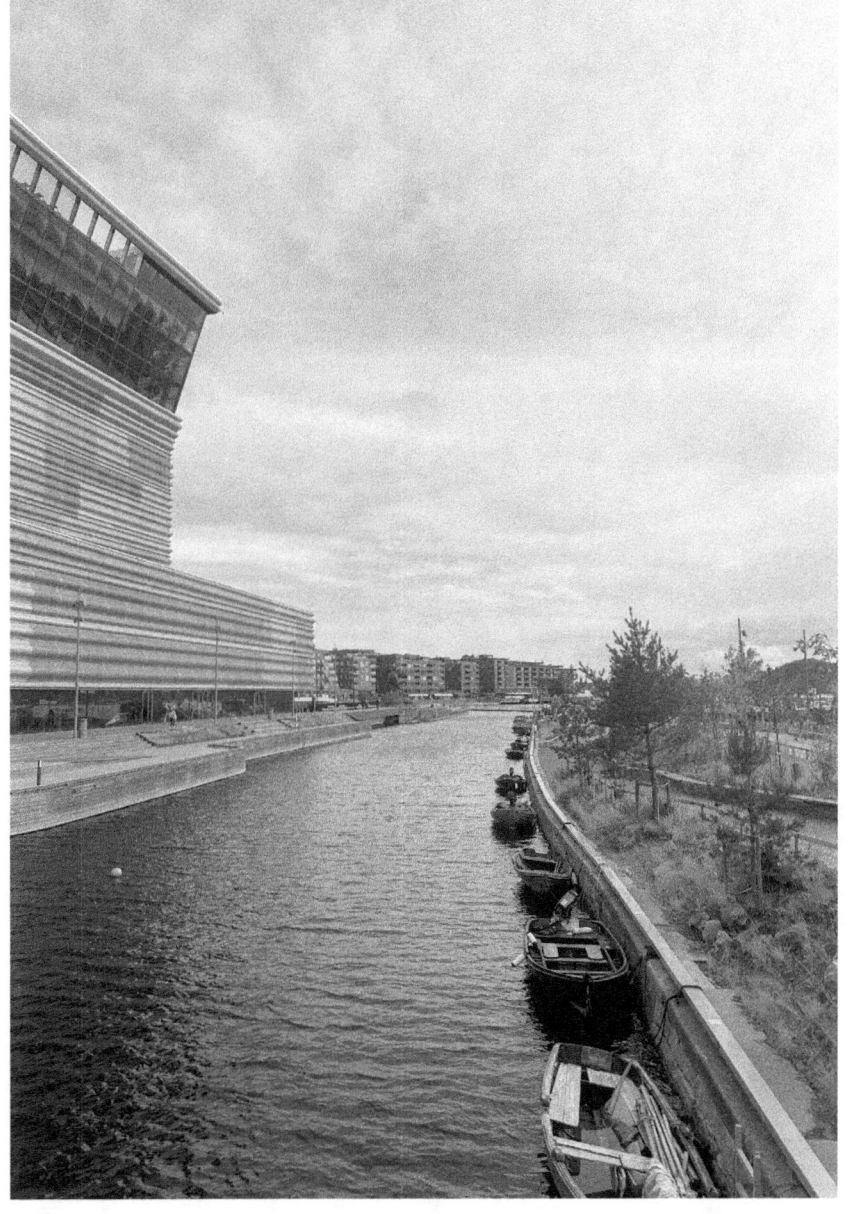

LAUREN COYLE ROSEN

IN THE END, THEY DRINK THE SUN

Those who play the fools
Who pretend not to know
Prefer the veils upon the eyes
Of those from whom they steal glow

In the end, they drink the sun
And swallow their own demise
Eternal fires cannot be ill-won
They cannot even be met by eyes.

ETCHING FATE

Flowers of evil rot in sunlight
They cannot grow by days
All they can take are tears bright
With stolen vital force in greys

Pallid frames of bygone lives
Vacant eyes and shrunken souls
Here, the bodies serve the knives
Etching fate into ever-deeper holes.

SOLARIUM

LAUREN COYLE ROSEN

LIGHT WASHED IN MOON

Endless expanses of soul
As she meets the horizon
Indifferent in its radiant pull
Vastness takes measure of none.

Seas hit the meter like time
Cafe porcelain each noon
Seagulls bless silvery fine
Evening light washed in moon.

BEATS THE MAGMA HEART

At the center of the earth
Beats the magma heart
Magnetism moves the worth
Of the spirits that bring the art

The windows at sky lines
Oceans fall in the deep
Edges of worlds, signs
Of coming days to reap.

SOLARIUM

LAURENCOYLE ROSEN

SOLARIUM FIRES

Reign of the sword, she greets
Each day with solemn laughter
Striking the cruel and foolhardy
With solarium fires upon water

Sure as sun sets in rhythm
And blood courses through veins
Reciprocal consequence hymns
Fall upon all beyond names.

SUNS UNFURLED

Dreamworld and her essence bare
Whatever of the tethers to world
The games the people play with hair
Discus thrown into Suns unfurled.

Tunes that draft through cavernous
Minds and bodies and spirits
In drafts and subtle breeze caucus
Maze of threads unwinds in fits.

SOLARIUM

LAUREN COYLE ROSEN

PUREST GOLD IS NOT DRAWN

Sheen of promontory
Heads the holy haze
Wreathed in allegory
Sunlight without rays

Darkness in minds
Wreaks havoc upon
Forges for fool's finds
Purest gold is not drawn.

LEVELING ALL IN HER GAZE AND OUT

Jubilation paths lit with tapers
Oil lamps and sea salt air
Apparitions visit in the vapors
Thousand veils in her hair

Her eyes burn suns without
Apology or hesitation, she floats
Leveling all in her gaze and out
Fire lamps kneel to her coat.

SOLARIUM

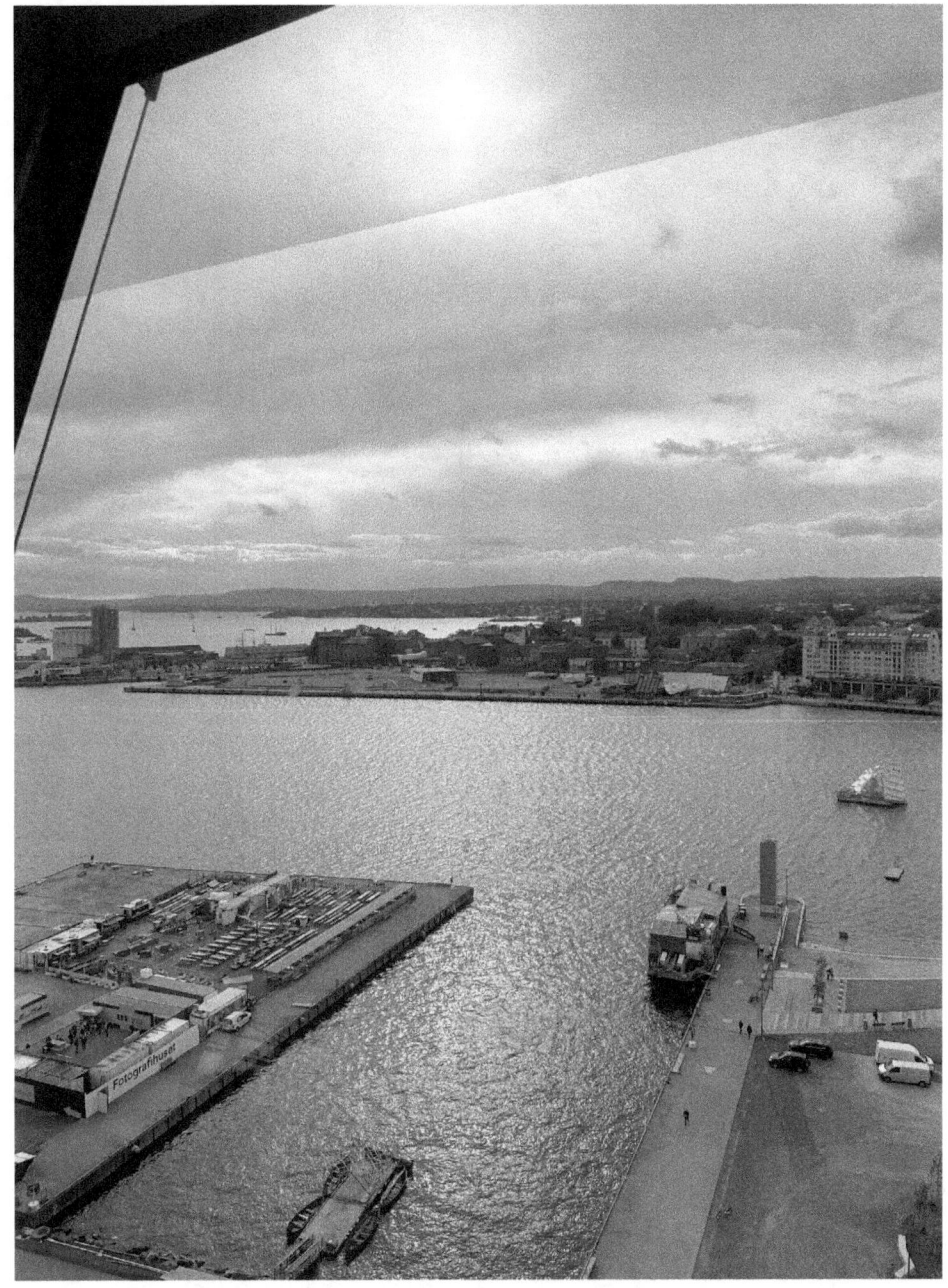

LAUREN COYLE ROSEN

GRAVEL SUNRISE

Gravel sunrise hits her eyes
Fall to the wind at the corner
Silhouettes ask the flame why
She passes right through former

Phases of frames and walls
Bridges so thrown with force
Unifying ends of solemn tall
Billiard ball, intersection course.

TENDER LESSON

Page that speaks her times
Essence of tomorrow's fate
Bells intone shedding pines
Snakes with new skins prate

Violin dances to ears in arch
Acoustic languid cathedral
Scrolls beyond words of research
Universe in tones of spiral.

SOLARIUM

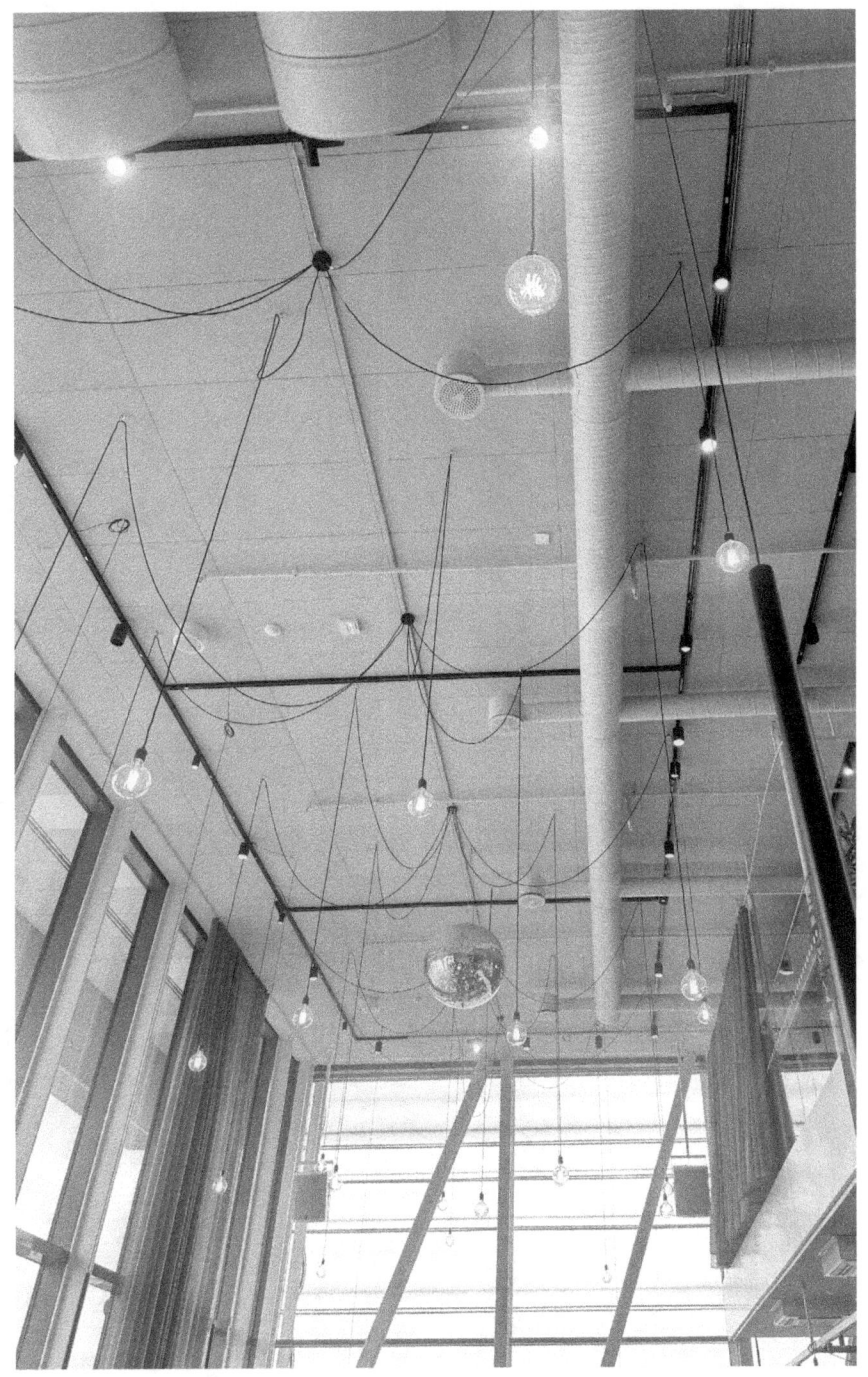

LAURENCOYLE ROSEN

SILVER DOORS ON THE SEA

Sailed to the edge of the moon
Dock at her plaintive crooked
Edge with the silver door room
Aloft like a ghost palace hooked

From the deepest expanse of sea
Waterless worlds, envy the sight
What is torn from interior frieze
Sanctifies ship-worn, day to night.

WHERE THE RAIN HITS EYELIDS

Where the rain hits eyelids
Sleeping skies wayward blue
Quest for essence, nothing forbids
Shaded lanes draped in dew

Who felt you ever, stone of wall
Standing only in memory or outline
Tracing the road past the first fall
Of the hill to the stream of sublime.

SOLARIUM

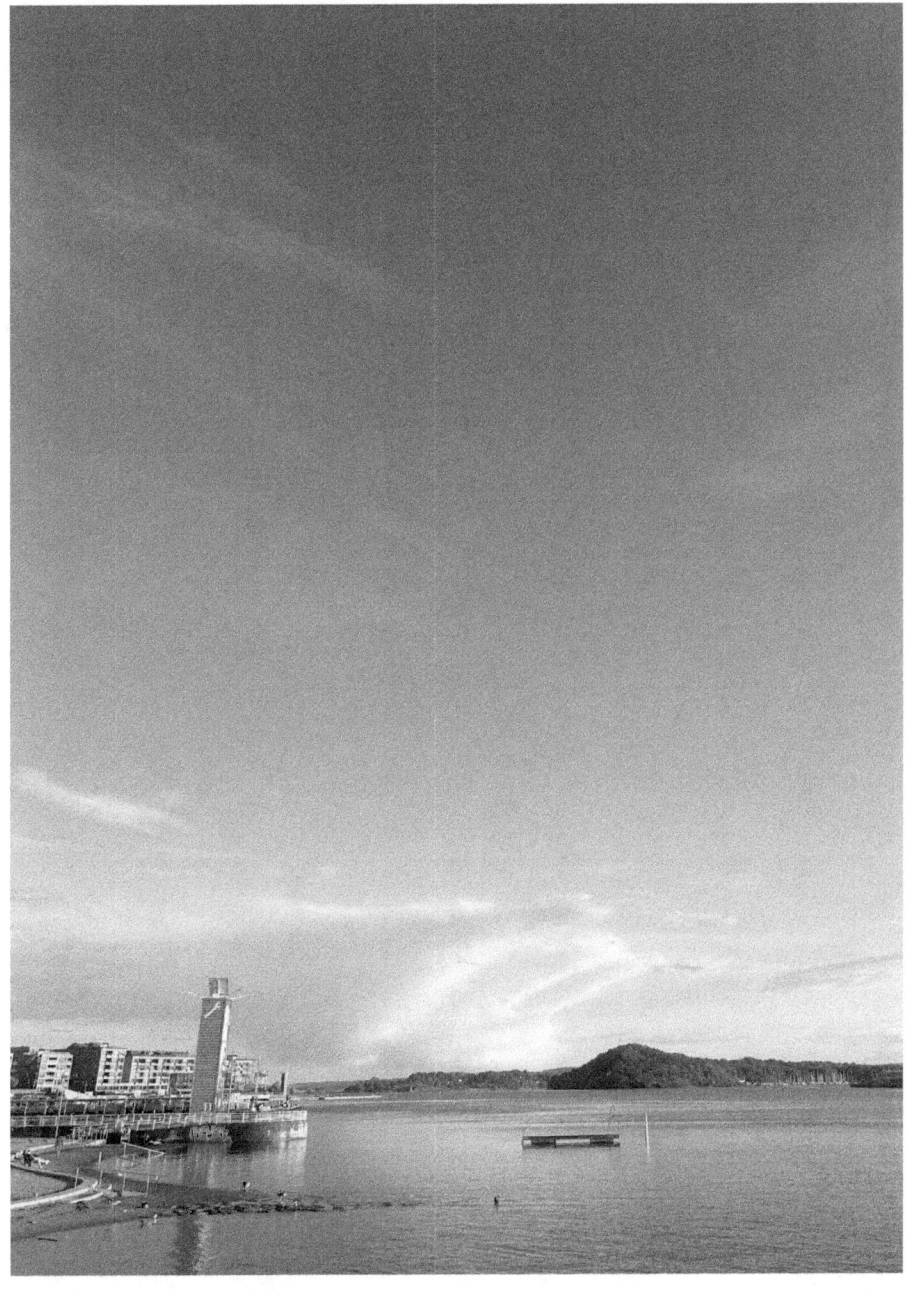

LAURENCOYLE ROSEN

NO GILDED TIME

Castles that spent their time
With inner realms, golden to vein
Nothing fenced, no gilded time
Razor gaze levels her words in plain

Truths as they tumble from mouths
Moved by the essence of rivers
Force courses through every route
Catacomb that opens and delivers.

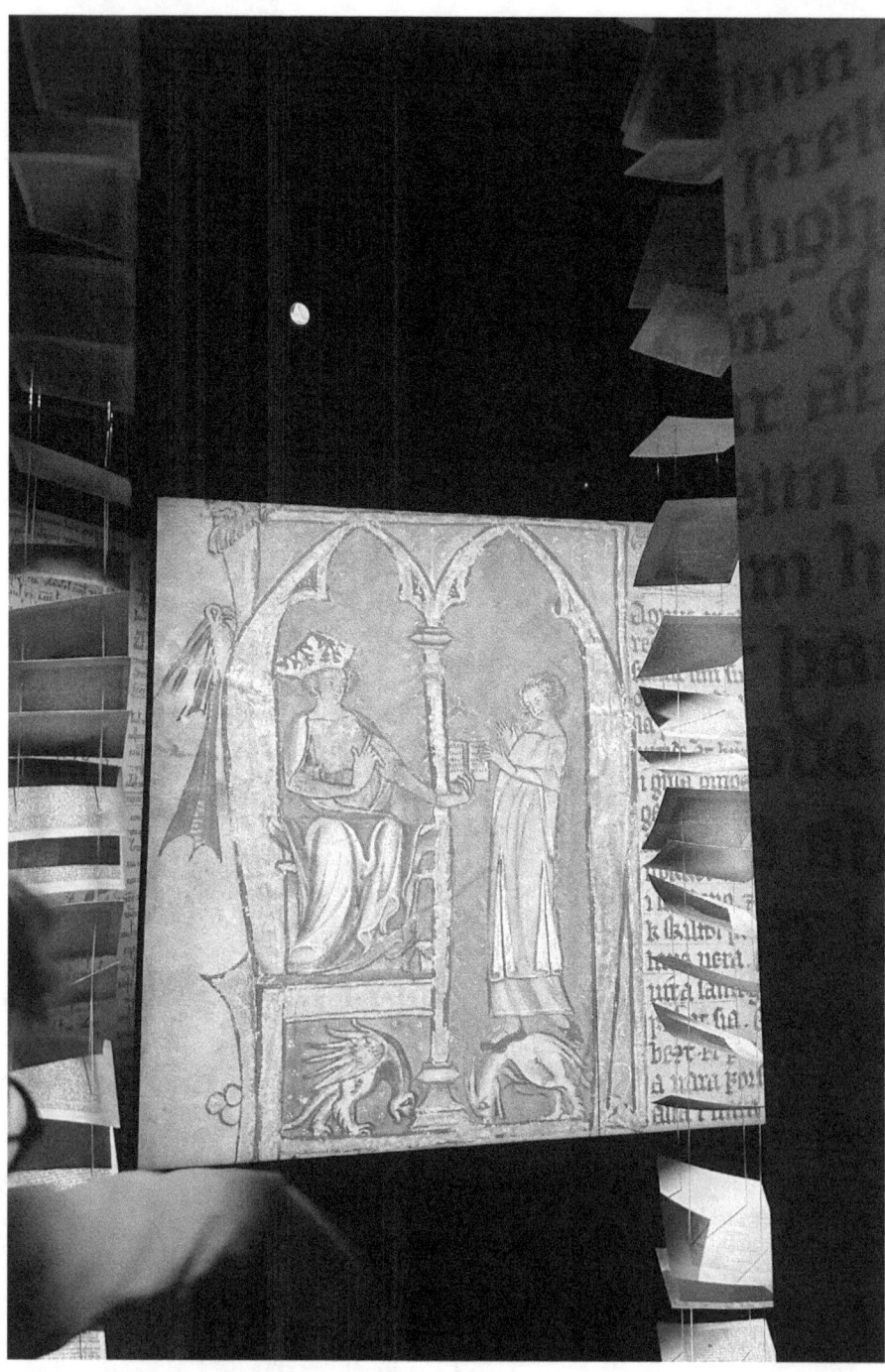

SOLARIUM

FIRE GOLD RING

Silver angel wings of eyes
That light the fires of reason
Coursing with paradoxical wise
Betray the truth of the season

Elders stand guard at hammered
Passageways that fold to bring
Destination to all beyond glamor
Restive springs and fire gold ring.

VESPERS

Flame that writes her age
At dawn across the sky
Threading lines as presage
Dim-lit room of storm's eye

Visiting face appears each
Night on the wind in tune
With harmonies beyond reach
Of word in fullest bloom.

LAURENCOYLE ROSEN

SOLARIUM

LAVENDER ROBES DRESS THE SKY

Lighthouse shimmers as the dawn
Drenched in moon and fires lit
Distant bells beckon waves upon
Fortress built on city's summit

Lavender robes dress the sky
Verdant hills recline in song
Lovers lost on a distant wry
Path through hyacinth long.

BELLS THAT BREAK THE TIME

Grasp the bells that break the time
Heal the bleeding scars of graves
Fill to the brim the cup of the wine
Called life that slays all the knaves

Holy in center the square and pane
Speech that unfurls like white flags
Whosoever unburdens the lane
From streetcars and unknown lags.

LAURENCOYLE ROSEN

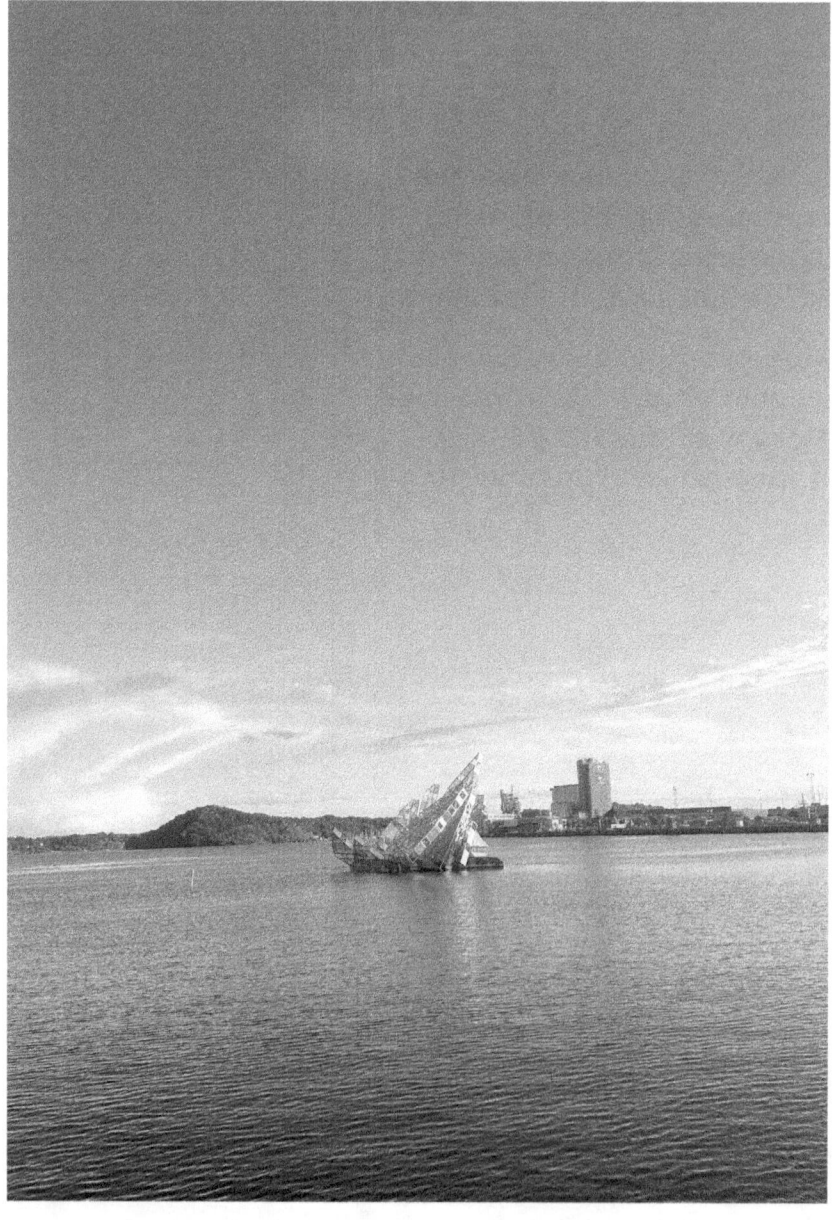

SOLARIUM

BARRIER REEFS OF SOUL

There is a threshold
Where soul meets sand
Beginning is foretold
Reef is porous and grand

Spirit realms that move
Beyond the sands' time
Speak so as to prove
Justice that brings line.

WINDOW BARE

Sweetest sounds hit window bare
Salted air and frayed sweaters
Threadbare blankets, orchards fair
Fructify ever the divine heathers.

Violins fall to the ages in force
Truest words always wrap song
Of bells from churches in terse
Oracles of beauty beyond wrong.

LAURENCOYLE ROSEN

SOLARIUM

AT CROSSROAD'S ONE

Write the word so that soul
May speak its light to the room
Minds clouded with vacant toll
Of base moves in darkness plume

There always was a low hum
That happened on the air when
Forces met at crossroad's one
Verified entrance kept within.

SOLARIUM

91

LAUREN COYLE ROSEN

ABOUT THE AUTHOR

Lauren Coyle Rosen

Lauren Coyle Rosen is a cultural anthropologist, artist, and the author of eleven books to date, four nonfiction books and seven volumes of poetry. Her prose books include: Hannibal Lokumbe: Spiritual Soundscapes of Music, Life, and Liberation (with Hannibal Lokumbe); Law in Light: Priestesses, Priests, and the Revitalization of Akan Spirituality in the United States and Ghana; The Spirit of Ani: Reflections on Spirituality, Feminism, Music, and Freedom (with Ani Di Franco, forthcoming); and Fires of Gold: Law, Spirit, and Sacrificial Labor in Ghana. She founded and writes for The Spiritual Muses, a journal on the creative and spiritual inspiration of artists, writers, and thinkers from all realms. She served on the faculty in anthropology at Princeton University, where she received the President's Award in Distinguished Teaching. She holds a J.D. from Harvard Law School and a Ph.D. in Anthropology from the University of Chicago.

www.ingramcontent.com/pod-product-compliance
Lightning Source LLC
Chambersburg PA
CBHW070113230526
45472CB00004B/1238